The Kitch

LEARNING TO SEE

If you've ever wanted to learn
to draw, or to draw better,
the Learning to See series offers
a mix of inspiration, encouragement,
and easy-to-complete exercises
that will have you filling the
pages of your sketchbook more
confidently in short order.

The Kitchen Art Studio

Peter Jenny

Princeton Architectural Press · New York

For Sela, Wyatt, and Giacomo

Published by
Princeton Architectural Press
37 East Seventh Street
New York, New York 10003

Visit our website at www.papress.com

Originally published by Verlag
Hermann Schmidt Mainz under the title
Wahrnehmungswerkstatt Küche © 2006
Professor Peter Jenny, ETH Hönggerberg,
Zurich and Verlag Hermann Schmidt Mainz.
The text of the English edition has been
adapted to the American market.
English edition
© 2015 Princeton Architectural Press
All rights reserved
Printed and bound in China
18 17 16 15 4 3 2 1 First edition

For Verlag Hermann Schmidt Mainz:
Design: David Schlatter

For Princeton Architectural Press:
Editor: Nicola Brower
Translator: Bronwen Saunders
Typesetting: Jan Haux

Special thanks to: Meredith Baber,
Sara Bader, Janet Behning, Erin Cain,
Megan Carey, Carina Cha,
Andrea Chlad, Tom Cho, Barbara Darko,
Benjamin English, Russell Fernandez,
Will Foster, Jan Cigliano Hartman,
Mia Johnson, Diane Levinson,
Jennifer Lippert, Katharine Myers,
Jaime Nelson, Rob Shaeffer, Sara Stemen,
Marielle Suba, Kaymar Thomas,
Paul Wagner, Joseph Weston,
and Janet Wong of
Princeton Architectural Press
—Kevin C. Lippert, publisher

Image credits:
Page 74: from *Asterix und die Normannen*
Pages 136–37: from an old recipe by
Peter F. and David W. from Z.

Library of Congress
Cataloging-in-Publication Data

Jenny, Peter, 1942–
[Wahrnehmungswerkstatt Küche. English]
The kitchen art studio / Peter Jenny.
 pages cm
ISBN 978-1-61689-365-1 (paperback)
1. Drawing—Technique. 2. Kitchens—
Miscellanea. I. Title.
NC730.J46513 2015
741.2—dc23
 2014045944

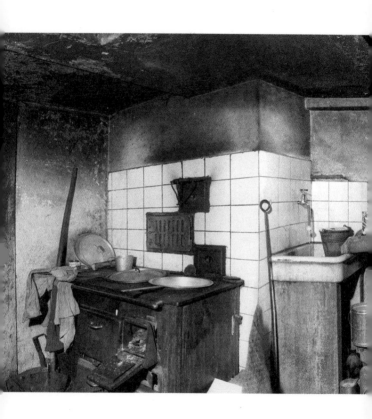

Once a kitchen, now a studio

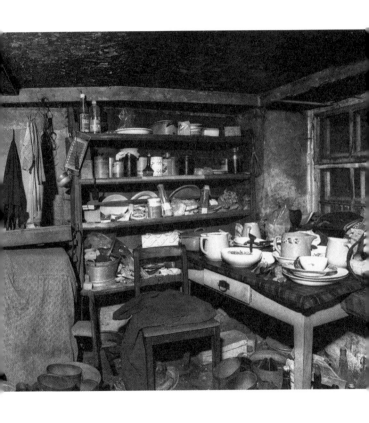

Foreword

"A rose is a rose is a rose is a rose…" The same could be said of a tomato, of course. While we all have common knowledge about what a rose or a tomato is and what it looks like, the art of perception allows us to discover differences in such everyday things and even in the great constants in life. Could it ever be said of a tomato that it is too ambiguous to end up in a salad? It could. And can cooking recipes and art recipes be intermingled? They can.

The outcome might not be anything special, but it will be something different. Paul Bocuse, for example, would see a very different tomato from Andy Warhol, which would be different again from the one seen by Jamie Oliver, to say nothing of Giuseppe Arcimboldo, Peter Fischli, and David Weiss. So as you can see, not only do fruits and vegetables become hopelessly muddled in this book, but the somewhat

distorted depiction of them is intentional, its purpose being to inspire perceptual art experiments of your own in a place where so much of the "world" comes together—in other words, in your kitchen. Your kitchen makes an ideal studio for transforming foodstuffs into the stuff of perception. The kitchen of our childhood is the one that stays with us our whole life long. Here, our early love of experimentation, of sampling new things, produced experiences that influenced our perception with lasting effect.

Beauty, of course, can't be conveyed by a recipe alone, as the following example illustrates all too well: "Mix 60 mg of water with .7 g of protein and fat and add .4 g of salt. Fold in .16 g of glandular secretions and several million bacteria."*

*Recipe for a French kiss that I read somewhere in a book by Péter Esterházy, who for his part read it somewhere in a book by somebody else.

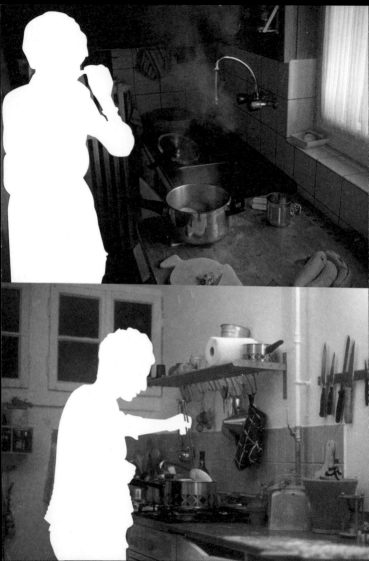

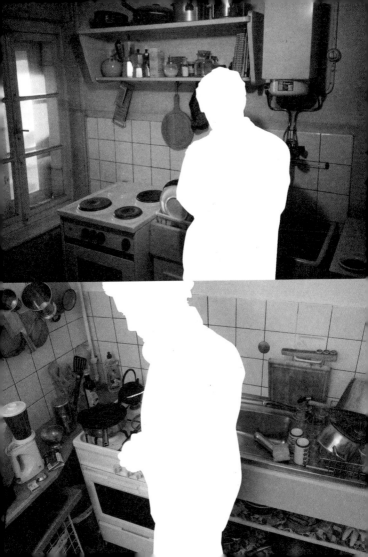

Introduction

The kitchen

Even people who don't cook like to spend time in the kitchen, if only because most homes have one. A kitchen that is used for cooking day in and day out may seem like a relic of a long-lost culture; yet it is still something we are all familiar with. It is the sum of the activities taking place in the kitchen and the memories we have of them that forms the backdrop for the exercises in this book. The perceptual patterns that we have come to know here can be modified by regrouping and isolating objects, or by finding a new order to organize them. By changing our perception in this way we will discover the beauty of the everyday and develop new aesthetic preferences. Even TV dinners are not without potential as games for the eye, nose, palate, stomach, and hand.

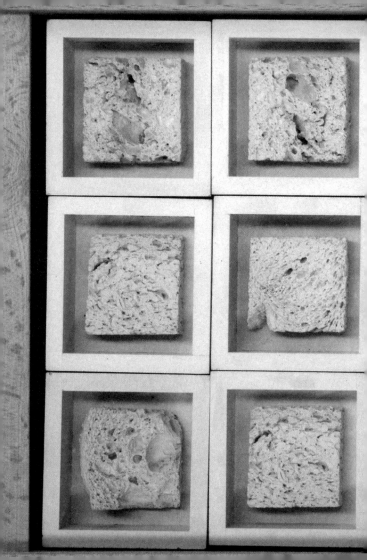

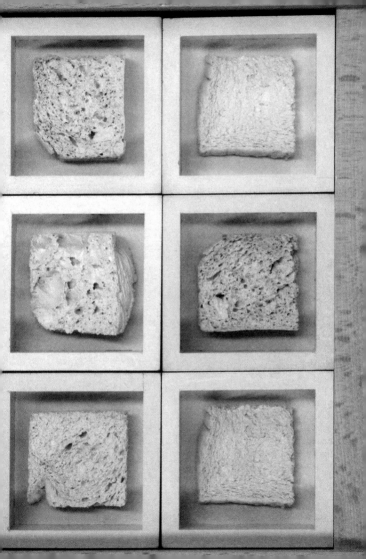

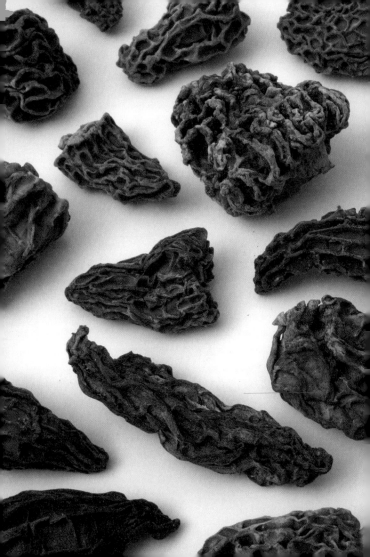

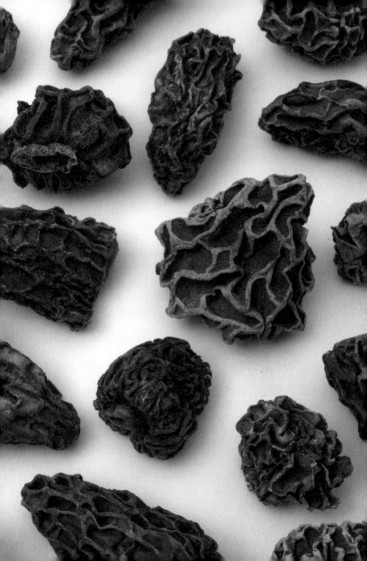

Seven principles* for the kitchen art studio:

Every human being is a perceptual artist. The purpose of the kitchen here is to enable us to discover this.

Linking my "non-artistic" abilities to an artistic technique changes my measure of value and allows me to appreciate things that I usually regard as ordinary and to see them in a new light.

My personal skill set, developed either professionally or in everyday life, forms the basis of my artistic engagement. (Cooking is interchangeable with other activities.)

Art does not have to look like art. It arises out of unusual combinations. It can even look like *cuisine.*

 Changes come about as a result of shifts and transformations. Scarcely anywhere else is there so much shifting and transforming as in the kitchen.

 Transfer is a highly entertaining and creative artistic method; we make use of it when we repurpose the kitchen as a studio—one that is open for all to see.

 A lot of knowledge is passed on when cooking, just as it is in art. Yet the preparation of meals can still be individual, even unique, which is another point in common with art.

*Sometimes the small print is important.

Just think of the ambiguities inherent in a slice of bread or a handful of morels!

Among the byproducts of cooking, alongside what is actually cooked, are the trails it leaves behind. Following these trails, which will ultimately lead us not so much to dinner as to a change in how we perceive things, is relatively easy in the kitchen. There is a definite possibility to find something noteworthy even in a few crumbs. What at first might seem like a mere pastime is in reality an artistic practice with a long tradition behind it.

How can a simple kitchen be at once a perception workshop, storytelling space, organ, time capsule, studio, cosmos, and a kaleidoscope?

Processes of transformation are an essential aspect of cooking. This inalienable law of the kitchen offers a wealth of creative forms that we only have to observe to make some surprising discoveries. We could compare the kitchen to

a kaleidoscope in this way. The multicolored splendor of the kaleidoscope is generated by movement and mirroring—unlike the eye, which generates its gaze through movement in the mind. The word kaleidoscope combines three Greek roots: *kalos*, meaning "beautiful," *eidos*, meaning "idea," and *skopéo*, meaning "I see." The ability to project beauty, ideas, and perception into the kitchen, or even into a piece of bread instead of a few splinters of colored glass, rests on mental powers that we all possess. Our eyes, noses, ears, hands, and mouths can be imagined—and illustrated—in connection with the respective senses of sight, smell, hearing, touch, and taste. There were times when the kitchen was the nerve center of the home. The kitchen as a place where meals are prepared, and in some cases eaten, is something that everyone can relate to; young people, especially, like to cook and eat together, or even just to hang out there.

Imagine only ever sitting in such a kitchen, as if the kitchen were your whole world. You would follow even the most trivial sources of stimulation. A dusting of flour on your hands would become a snowdrift; water boiling in a kettle would become a gushing mountain stream; the sizzling of the frying pan would conjure up visions of whitewater canoeing. Our past experiences and memories are contained in these interpretations, even if at the back of our minds we know that it is actually only a simmering saucepan that is firing our imagination, and not, say, breakers crashing into a cove on a wind-lashed coastline. We are accustomed to regarding the twin concepts of cause and effect as logically correlated, yet the logic quickly disappears if we change our perspective. Perception's cause is called imagination, and it is imagination that enables us to see a cookie as a waxing and waning moon, or the kitchen itself as the belly of some giant beast. Many intellectuals regard the belly as animalistic and prefer not to even think

about the many meters of gut contained within us. The consequences of regarding the kitchen as some kind of abdominal organ would certainly be interesting. The belly says: "Hunger!" the head says: "Eat!" and the eyes say: "It could be something else altogether"—bringing us back to the imagination.

The unknown in the known

Foods familiar to us from the supermarket shelves look completely different when seen close up in the kitchen, either immediately before or while preparing them. And our view of them changes yet again when we discover them as pieces in a game—a game of perception. We can achieve this unusual perspective if we turn the age-old adage "Don't play with your food!" on its head. Ignoring the former ban, which most children know only too well but scarcely ever heed, can lead to surprising findings that extend far beyond the sphere of the useful. Playing with food may be a matter of course for children, but

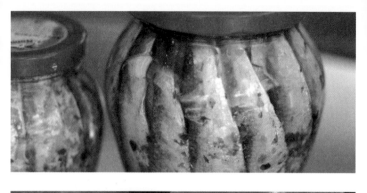

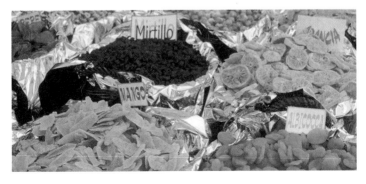

we as adults have to rediscover this game, in which kitchen waste encourages us to experiment before digestion clouds our vision. Washing, chopping, cooking, and eating are all activities that we do and vary over and over again, yet we have to start afresh every single time. This process is something that artists know only too well—returning to the studio to give their ideas new form time and again. Viewed in this way, the pastor's studio is the church, the IT expert's the computer, the teacher's the classroom, the architect's the office, the paper boy's the street, the farmer's the field, and so on and so forth. As German writer Wilhelm Genazino once said: "The poetic is something semi-authentic; one half (often actually less than half) is perception, the other half (often more than half) is fiction, invention, magic, surprise." Applied to what we keep in our pantry, refrigerator, or in the kitchen closet, the semi-authentic is what counts. And the ability to see poetry—or art— in it calls for a "special" gaze. When the

pastor, the IT expert, the teacher, the architect, the paper boy, the farmer, or the man or woman cooking in the kitchen start to take charge of perception within their own established domains, they are on their best way to develop this special, artistic gaze.

The kitchen art studio

Most of us have a kitchen at our disposal, which is reason enough not to resist the temptation to regard and use it as a studio. An "artistic view" can be brought to bear on a wide range of things; anything can become art, even kitchen waste. We can see images everywhere; we only have to learn to let it happen. As schematic as this process may appear at first, it nevertheless can be individualized, just like the preparation of a meal. Most activities occurring in the kitchen have something in common: the constant switch between the fast and the ponderous, the hectic and the serene. Procedures in the kitchen can be planned by following a recipe, but even recipes

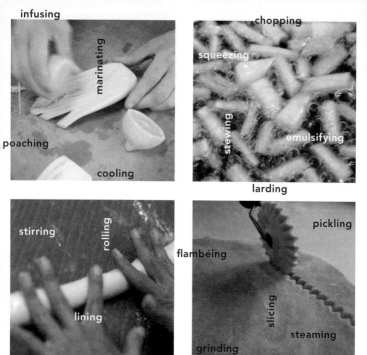
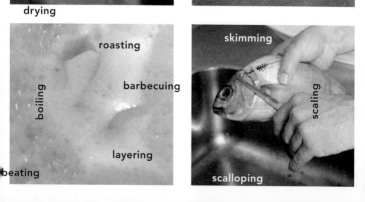

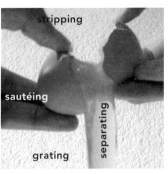

stripping

sautéing

separating

grating

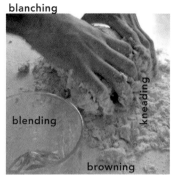

blanching

blending

kneading

browning

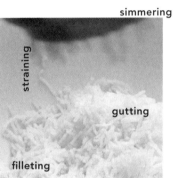

simmering

straining

gutting

filleting

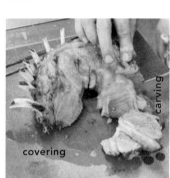

covering

carving

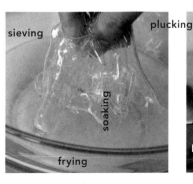

sieving

plucking

soaking

frying

reducing

braising

peeling

deglazing

can be rewritten to achieve slightly different goals. Found objects and readymades are both art concepts that can be applied in the kitchen, encouraging us to discover new qualities in familiar things. The declaration that there is more to the kitchen than just the preparation of meals—just as there is also more to the studio than just painting, chiseling, and drawing (one may even cook there)—reminds us of the countless possibilities that we can open up merely by reversing the usual order of things.

Chance

That chance has a major role to play in this game is beyond dispute. But recognizing what chance throws our way calls for a heightened awareness that is not so easy to muster, especially not in familiar surroundings. There is a lot more of the extraordinary in the ordinary than we care to believe, and only when we become perceptually more ambitious do we begin to notice the special where previously we had seen nothing worth

noticing. Viewed in a new light, a splash of sauce on the stovetop—as long as it is not simply wiped away—can take on meaning, or we might be reminded of it later by a picture that otherwise has nothing whatsoever to do with a dirty stovetop. Creative thinking makes use of comparisons, enabling us to detect similarities in content that could scarcely be more different. A product of chance suddenly becomes a point of reference, thus escaping the volatility of the instant.

Cultivating observation

Discovering something can be very gratifying, even if we discover it in something as humdrum as kitchen spills. This underscores the importance of the art of observation, which is just as crucial as the object that is being observed. The kitchen is the last workshop to be truly accessible and known to (almost) all. This makes it a good lodestar by which to navigate our way through the movable world of our own creativity. Even just renaming the kitchen a studio changes

our perception of it. While the average person goes into the kitchen to prepare food, the studio that used to be a kitchen is more likely to become a setting. Anyone who discovers amazing figures in plumes of steam, entire landscapes in kitchen waste, arcane patterns in a chaotic pile of dirty dishes, philosophical messages hidden in recipes or food labels, will, through these efforts, once again become what we all have always been (before we became a pastor, IT expert, etc.)—in other words, an artist. Even the alleged "inability" to do something brings with it the freedom to simply do it differently. We train our powers of perception by trying things out, by experimenting, just as we do when cooking, even if cooking itself is not the paramount goal.

Experimenting

To experiment means to collect and shape impressions, to transform the things we encounter. Lending expression to a tomato does not mean to show what it is but what it *also* is.

Even a humble tomato can animate our sensory impressions. Playing with conventions of perception can change our sense of beauty, and familiar things can become full of surprises. To be inspired we must allow ourselves to be influenced, and as the possibilities for being influenced are infinite, it follows that perception is by its very nature pluralistic and polymorphous. Start playing with your food and you'll soon discover this for yourself!

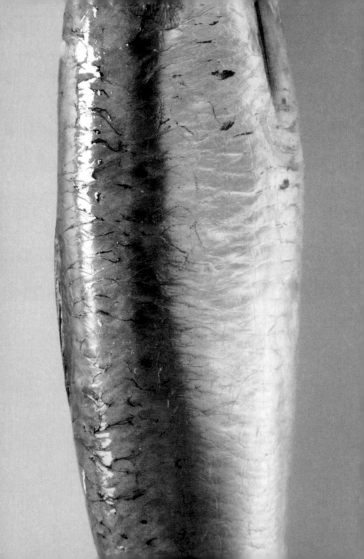

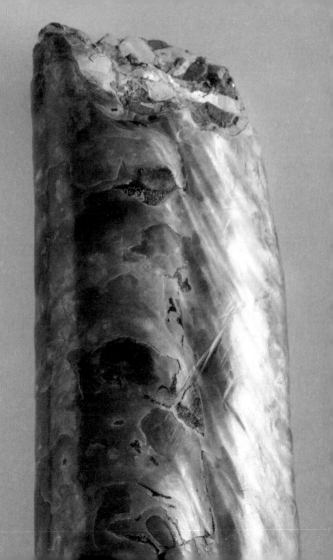

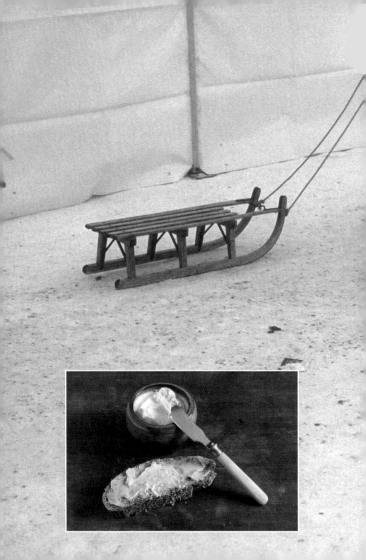

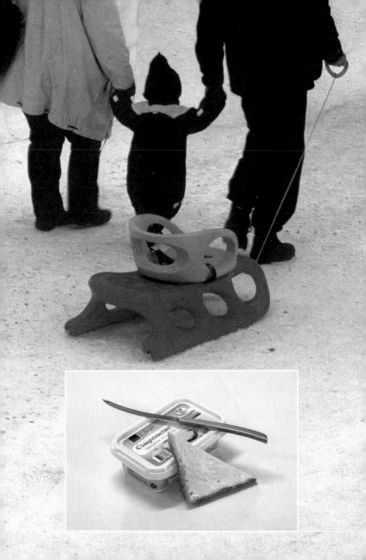

1

Chance

Chance favors those who keep their eyes open and retain the capacity to discover unforeseen order in disorder. Chance cannot be planned and precisely because of this—because it is independent of previous ideas—it augments our pictorial repertoire. Be inspired by what you find by chance. Rely on your intuition and aesthetic preferences.

Pages 42–47: Instead of tidying up, discover the order in disorder.

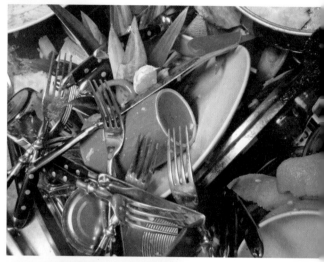

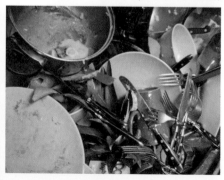

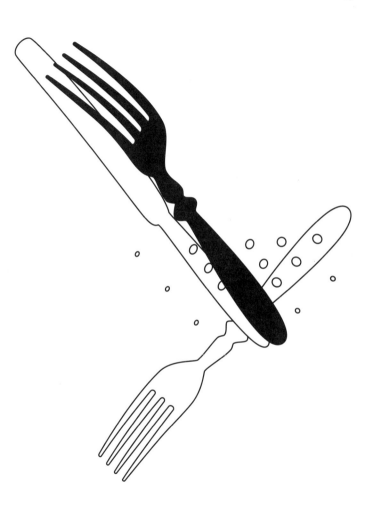

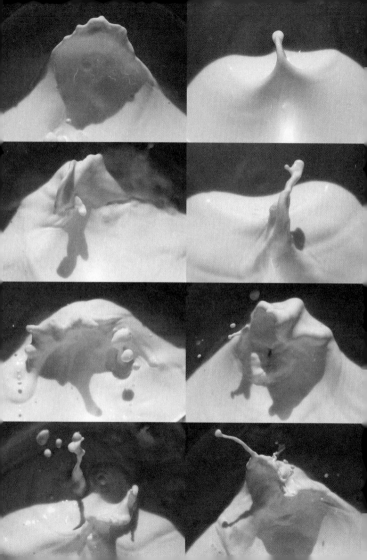

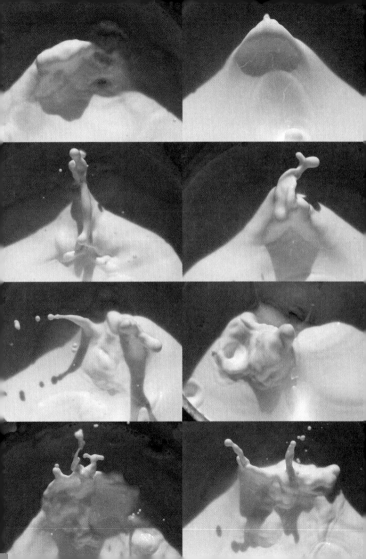

2

Found Objects

Objets trouvés can be found anywhere, especially when they seem "worthless" or unimportant. The clearly delimited space of the kitchen provides the necessary boundaries to the infinite number of possible find spots. What we find can be named or not; it can belong to a thematic group, or it can be one of a kind. The act of collecting is of central importance, as is the creation of new correlations. Found objects trigger memories, which can be the reason for collecting them. What objects can you find in your own kitchen that resonate with you in this way?

Pages 50–55: Chicken, lamb, and fish trouvés

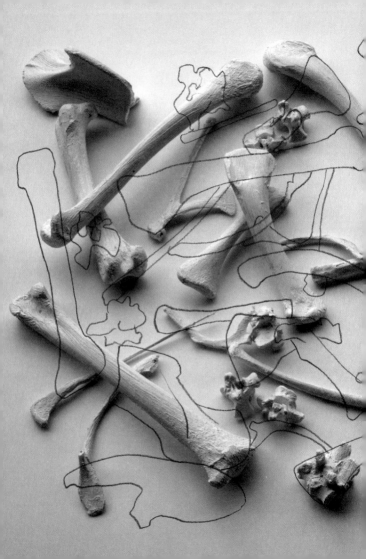

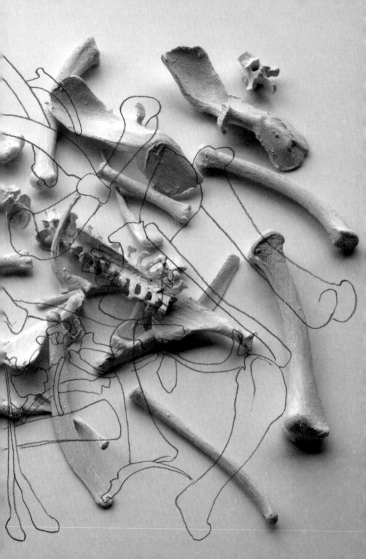

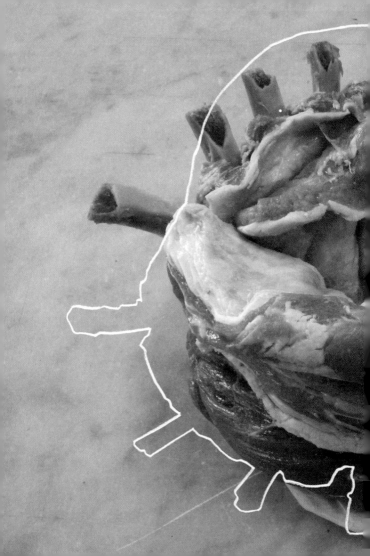

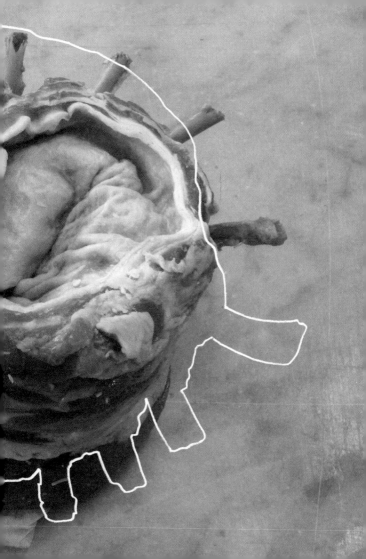

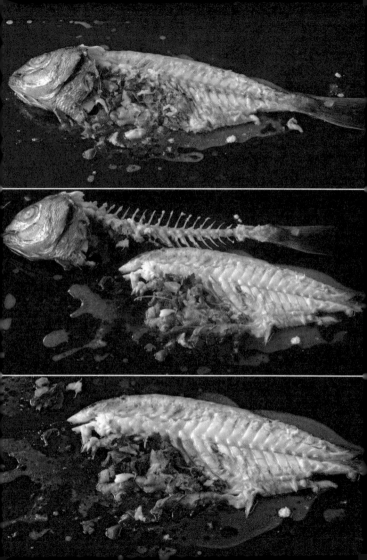

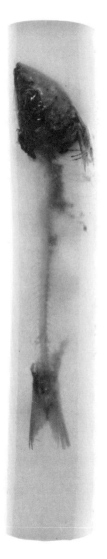
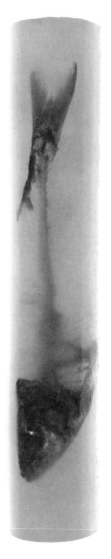

3

Ambivalent Values

Simply declaring something to be valuable is not enough; a variety of circumstances favors a new appreciation. Something might be rare or be in a museum, for example; it might be connected with art, be very pricey or very old; it might be unique or simply coveted by many. How we value things arises out of our perception of them. It is not just what we see but in what light we see it that shapes our appreciation of it. Give objects or foods in your kitchen new value by giving them a new context.

Pages 58–61: Recalling art, from Rembrandt to the dishwasher

Safran
Zafferano

Gemahlen / moulu / polvere

Manzoni

Laib

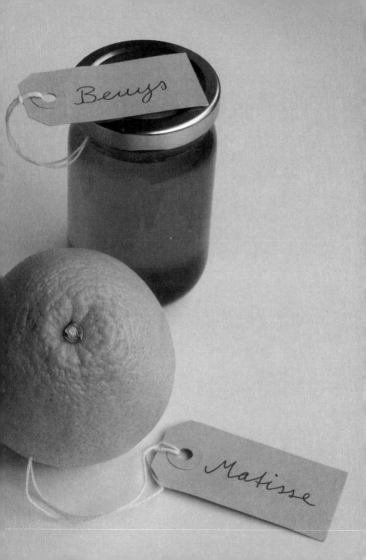

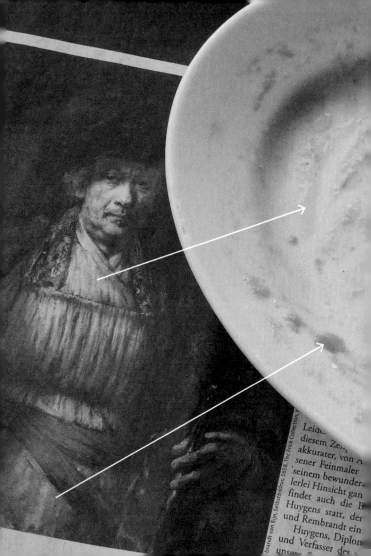

schwarzweiß abgebildet, doch
Anhang ist ein Detail dieses Gemäldes in Far-
ergriffen, die Linke, die das Zepter
fast gespenstisch zu sehen, mit
der Glanz dieses Zepters
eriert wird.
h die Sugges-
nd aus-
um

ister, ab
rs. Und im selben J
ung mit Constantijn
Ateliers von Lievens
ch abstattet.
eine Erinnerung an den Jüng
Rembrandt einst in
ronom K

4

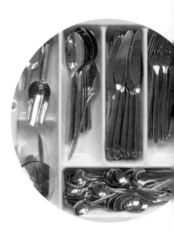

Order

Upholding law and order, at least in common
parlance, is the responsibility of the police, not
of authors, architects, artists, designers, cooks,
doctors, children, or fathers and mothers.
Creating and recognizing order is, however, an
elemental human need, since the eye is an
order-loving organ. Record the patterns and
order you find in your kitchen.

Pages 64–71: Order or disorder is a matter of perspective.
Page 72–73: The Rialto Bridge in Venice, Italy

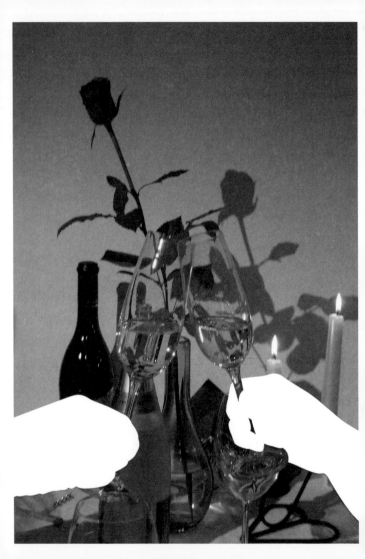

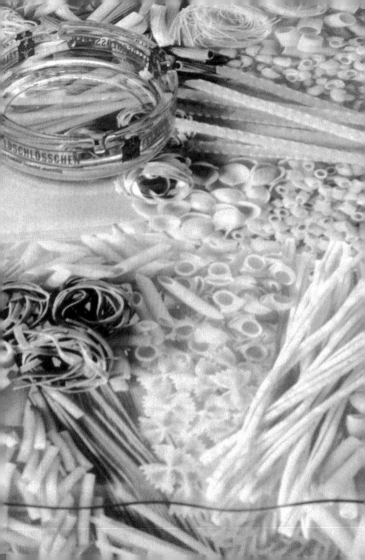

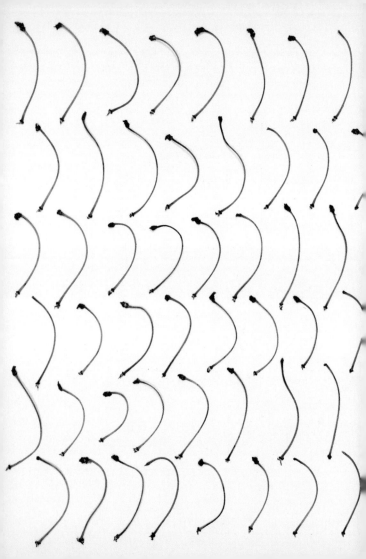

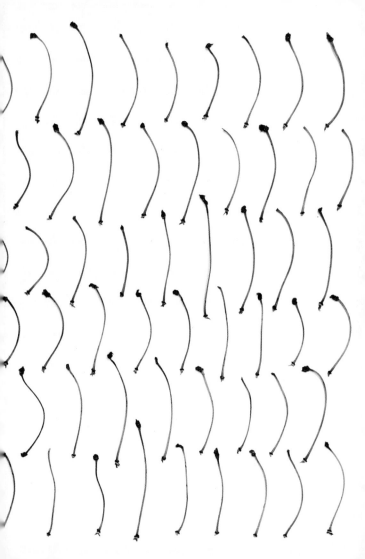

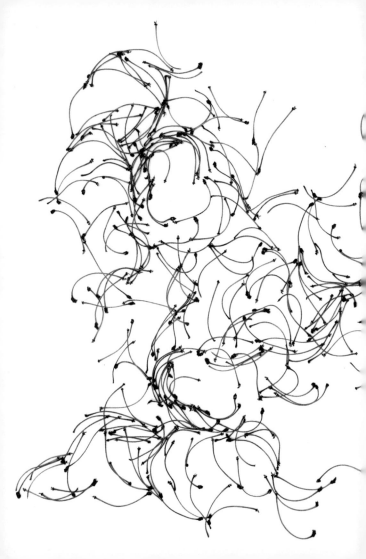

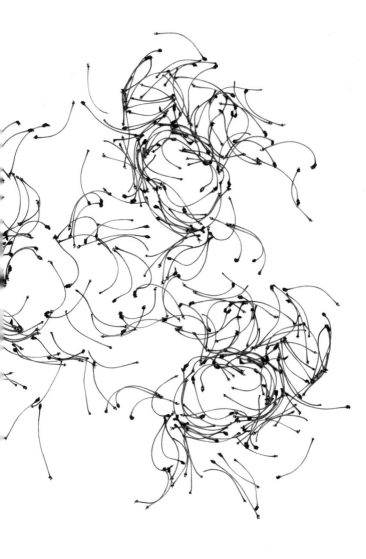

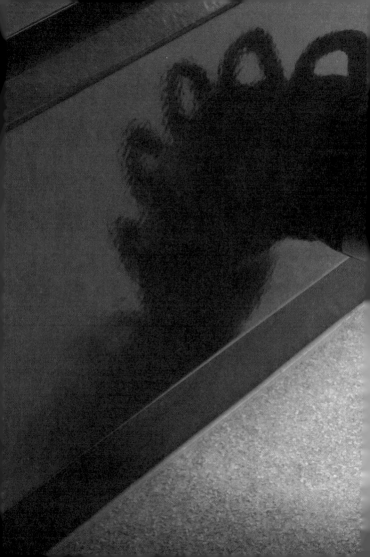

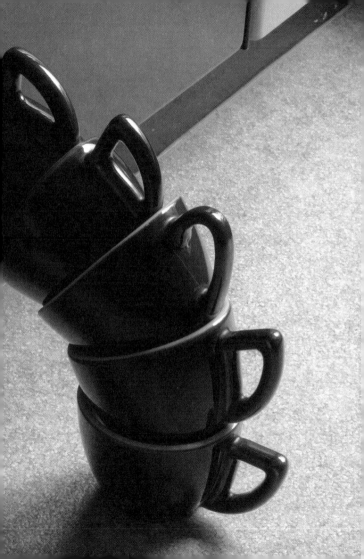

5

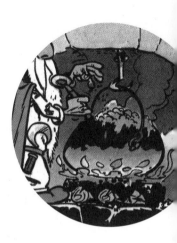

Recipes

There are books full of recipes in almost every household. Lavishly illustrated cookbooks are great for overdrawing and overpainting. The pictures they contain provide a rich stock of raw material for your own compositions. Usually you open a book in order to read it or to look at the pictures. For this exercise, however, develop a new aesthetic by creating disorder within the given order.

Pages 76–79: Overdrawn and overpainted cookbooks

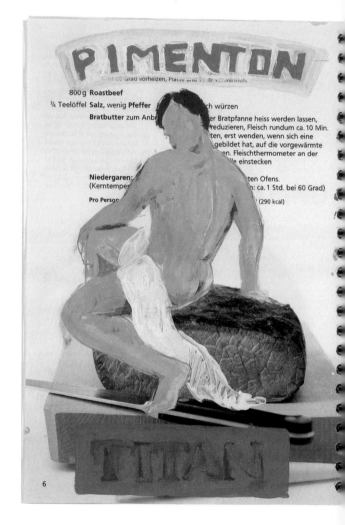

PIMENTON

... 60 Grad vorheizen, Platte und Teller vorwärmen.

800 g **Roastbeef**
¾ Teelöffel **Salz**, wenig **Pfeffer** ... ch würzen

Bratbutter zum Anbr... er Bratpfanne heiss werden lassen,
... reduzieren, Fleisch rundum ca. 10 Min.
... ten, erst wenden, wenn sich eine
... gebildet hat, auf die vorgewärmte
... en. Fleischthermometer an der
... le einstecken

Niedergaren: ... ten Ofens.
(Kerntemper... ...n: ca. 1 Std. bei 60 Grad)

Pro Person ... ' (290 kcal)

TITAN

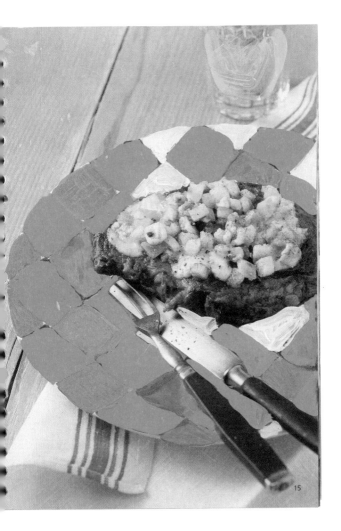

6

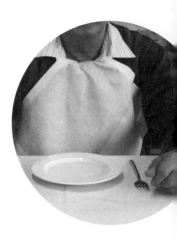

Trails

Whether in a fast-food joint, a pub, a private home, or a gourmet restaurant, the trails left in the kitchen look very much alike. Despite being left in completely different places, they share a common culture, which is short-lived as a rule, since restoring hygiene means removing them from view forever. There is not a single cookbook with a chapter devoted to such trails and smears. Yet it is here that we are likely to find most scope for the gaze to roam and to discover the beauty hidden in them. Study the trails left behind in your kitchen.

Pages 82–87: Looking for trails

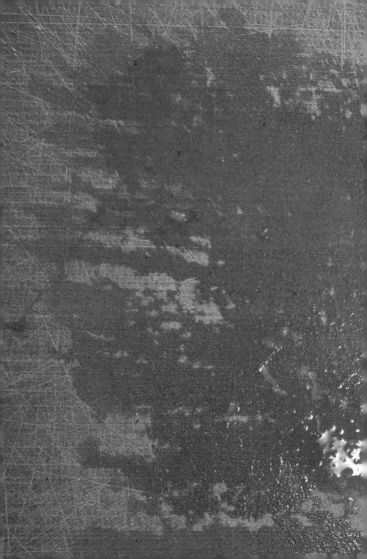

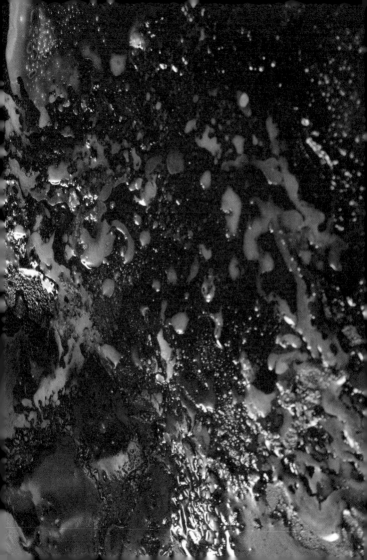

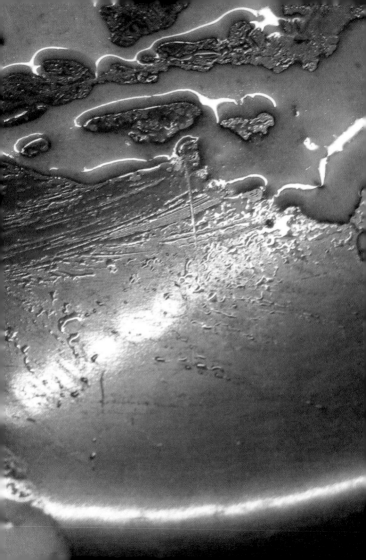

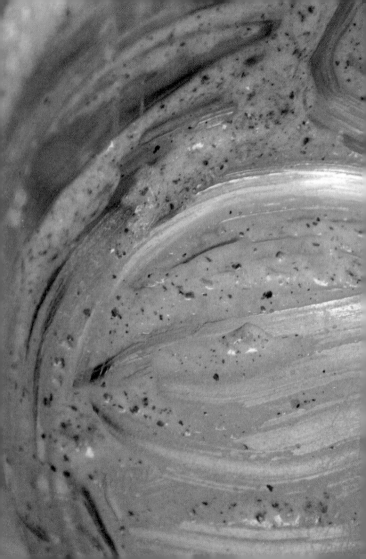

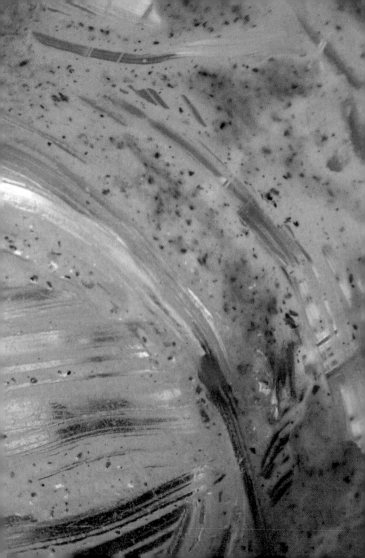

7

Silhouettes

Where there is light, there is shade—and silhouettes. A targeted beam of light can transform a scene of humdrum everyday life into something much more dramatic. The elongated shadow cast by an object forms a new picture, and the play of light source and illuminated object resembles the modeling and shaping of an image. Observe the changes apparent in an object compared to its silhouette and make them the subject of your picture.

Pages 90–95: The shadow remembers.

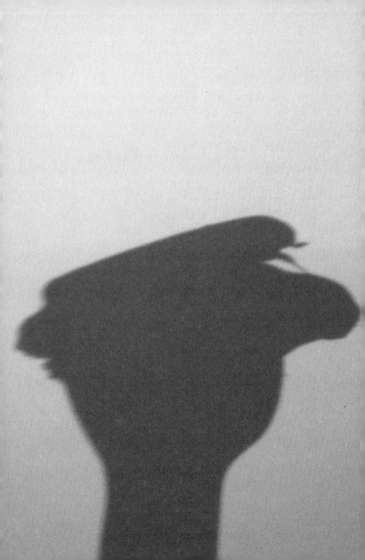

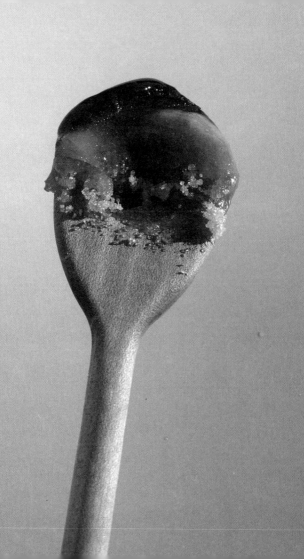

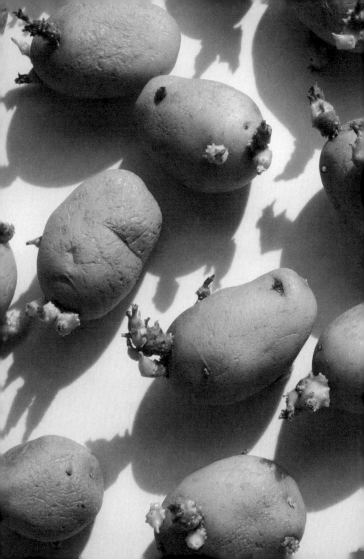

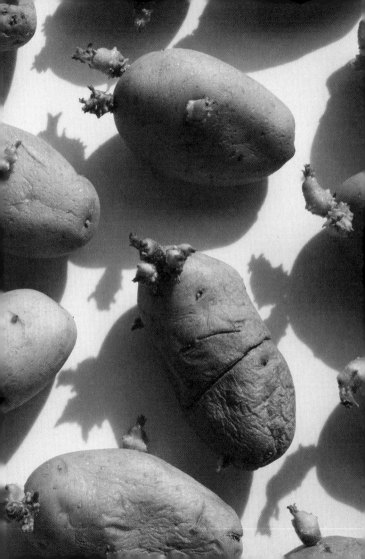

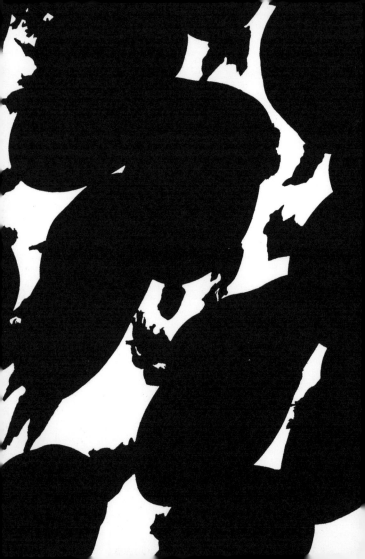

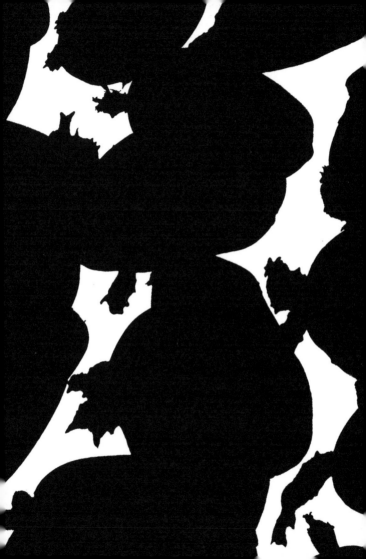

8

Wrapping

Packaging is of central importance when it comes to food. In most cases it is regarded as a necessary evil and quickly discarded after use. It does, however, provide anyone taking the time to scrutinize its shapes and materials more closely with a wonderful, cheap source of art supplies. The sheer ubiquity of packaging materials invites repetition and combination. Unfold it, trace it, or otherwise use it as the base for your images.

Pages 98–99: Unfolding new shapes

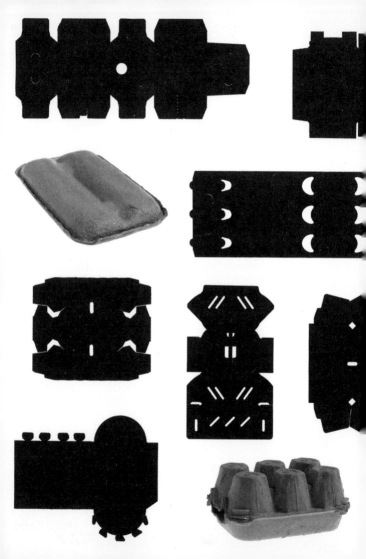

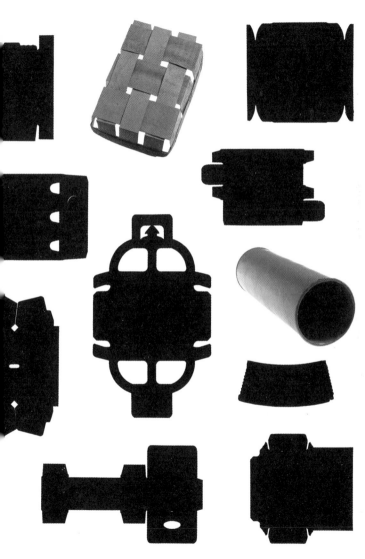

9

einschmecker kann
Gruppen unterteilen.
schneidet vom Toast di
die andere lässt sie drar
mit. Bei der ersten Gru
die Ästhetik die Essp
bei der zweiten die
edem ist es verständlich, wenn jen
e Toastbrot erst sorgfältig entrin
n den Toaster steckt. Da ist glei
e Rede, von der Sünde. Brot

Reporting

The events that people most tend to photo-
graph, write about, or otherwise record are
those that take place outside of normal everyday
life. The ordinary—a day at work, for example—
is rarely thought to warrant documentation.
Vacations, special occasions, and family celebra-
tions, on the other hand, are perceived very
differently; here, we see our stock of images
grow exponentially. Break with this tradition and
turn your gaze to the triviality of what goes on
inside the four walls of your kitchen.

Pages 102–7: Open-ended stories

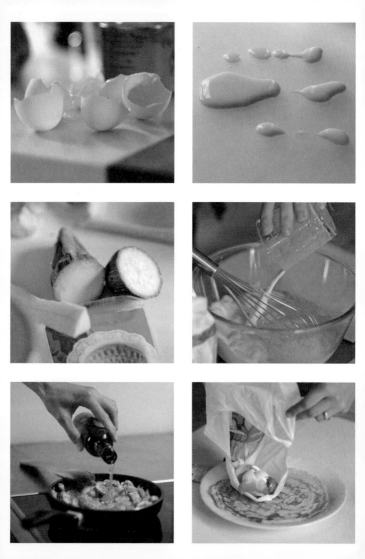

10

Change of Identity

Looking at things close up, paring them down to
their essentials, reducing them to a skeleton of
lines, detaching ourselves from the "natural"
view of things—all these methods expose
relationships between what is seen at first glance
and what becomes apparent to us only on closer
inspection. Viewed in this way a banal object
changes its identity and becomes mysterious
again. What mysteries can you discover in your
own kitchen?

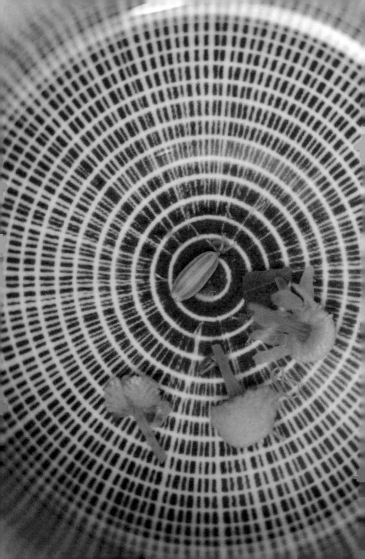

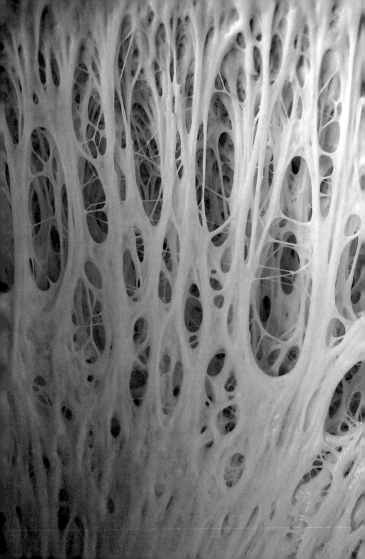

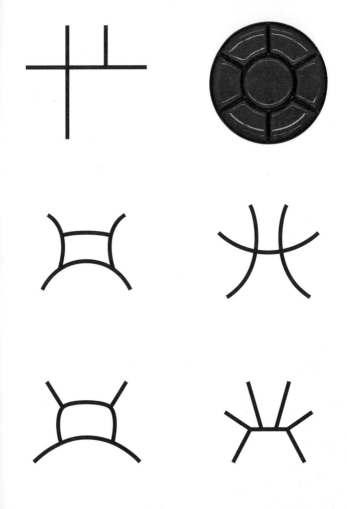

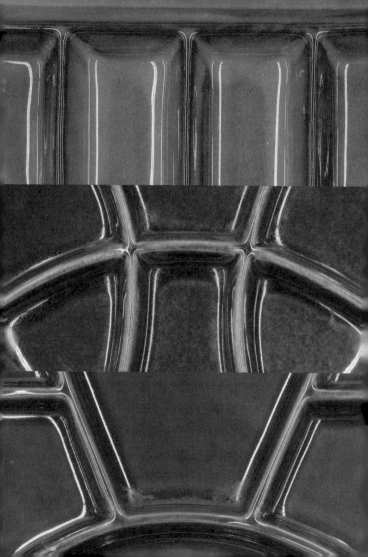

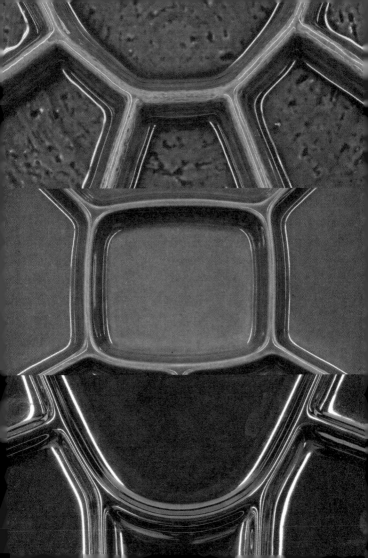

11

Colors

We are all familiar with the alluring array of colors on display at the local farmer's market. Inside our own kitchen, achieving the same opulence requires research that is more about the eye than the palate. Much of what happens in the kitchen looks as if painted, and colors play an important role in this. Go through the contents of your fridge or pantry, or take a moment while cooking to discover this world of color.

Pages 120–25: Laying it on thick

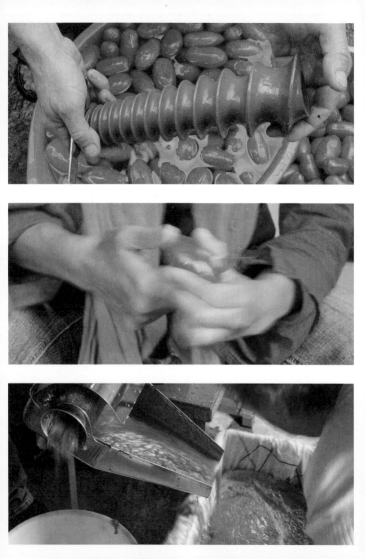

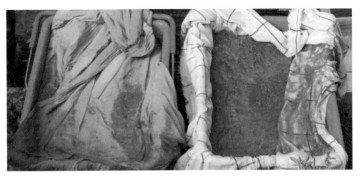

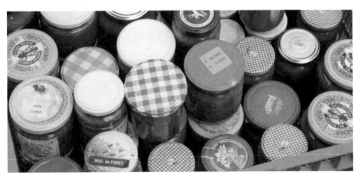

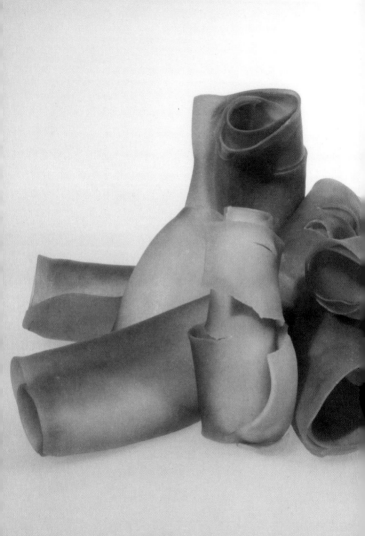

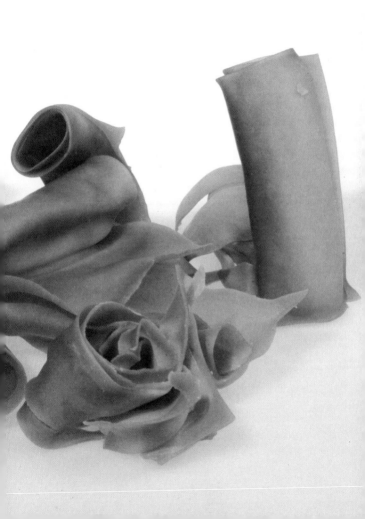

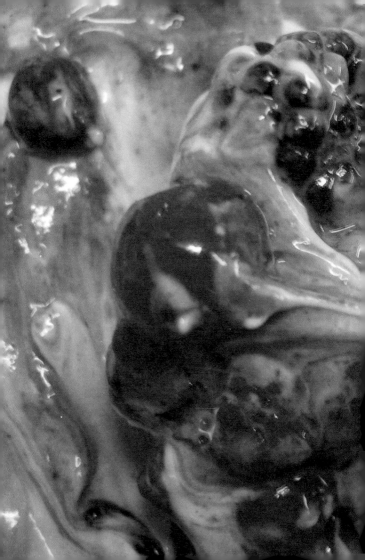

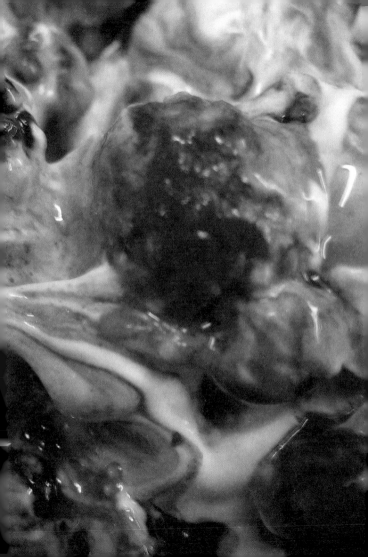

12

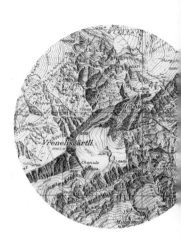

Topography

That we associate landscape paintings with real landscapes is hardly surprising. Discovering this same genre in the kitchen, however, calls for a little trickery. The right materials, the vantage point, and light conditions are all crucial factors here, as are certain formal similarities. Experiment with different materials to create "kitchen landscapes" of your own.

Pages 128–39: You can discover landscapes in even the tiniest kitchenette.

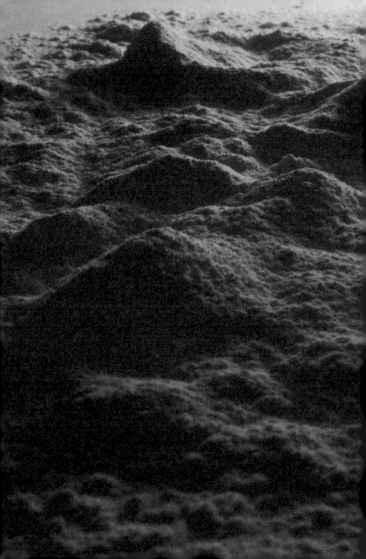

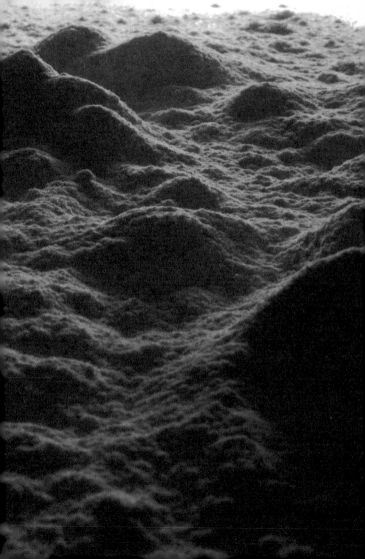

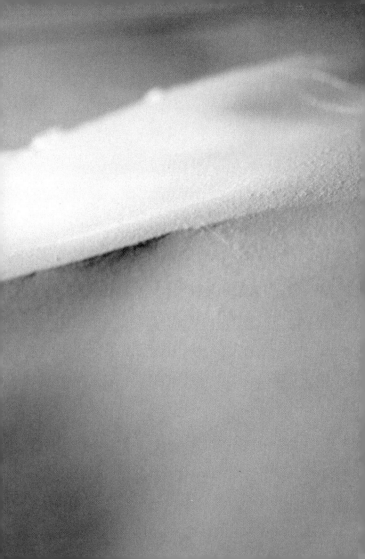

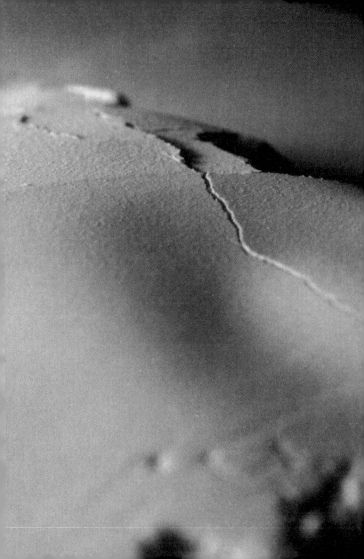

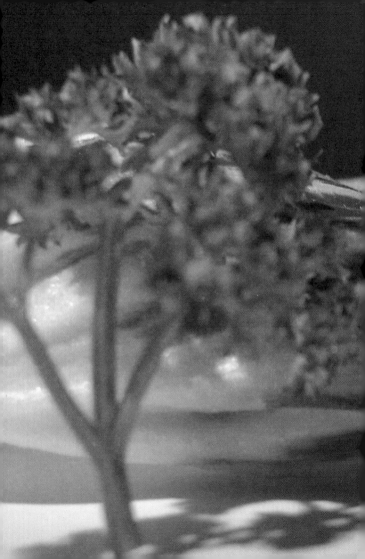

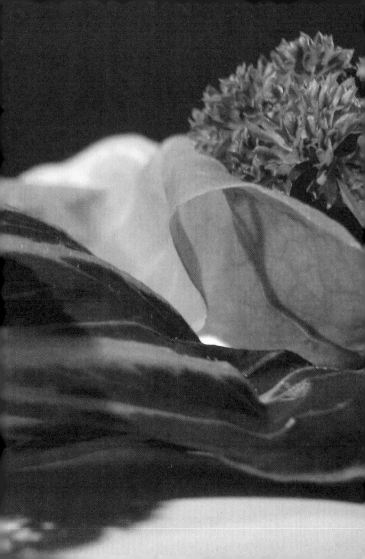

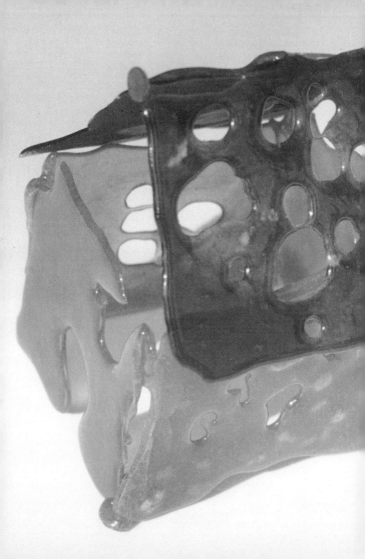

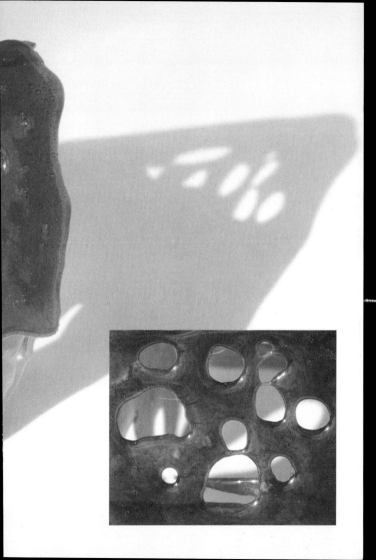

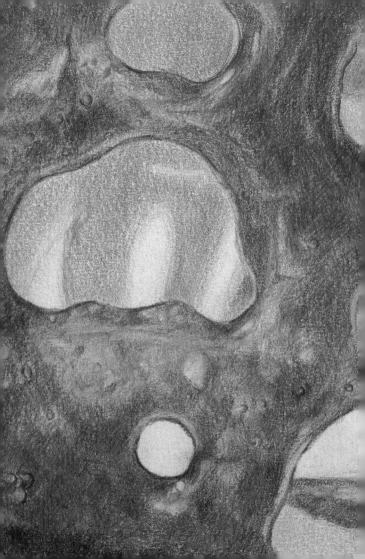

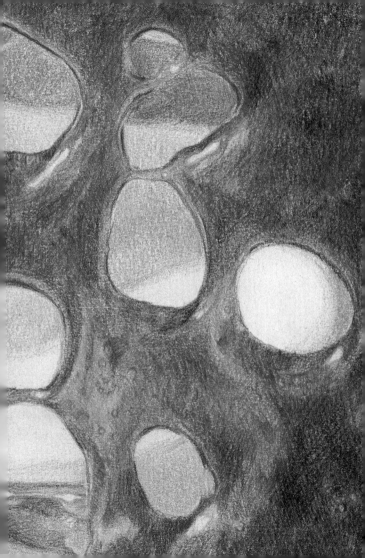

13

Refining

There used to be—and there still are, even if in somewhat modified form—image-making techniques and forms of representation that reinforced existing hierarchies. Having your likeness painted in oil meant that you were of a higher rank than those who were merely sketched or snapped. A bronze statue still carries more weight—both metaphorically and literally—than does a mere plaster cast. Content and form also determined what was felt to be appropriate or presumptuous. This prejudicial way of seeing cries out for reform: make a point to choose the fleeting, the unassuming, the banal for an image made with a "refining" technique.

Pages 142–47: Beauty thanks to technique

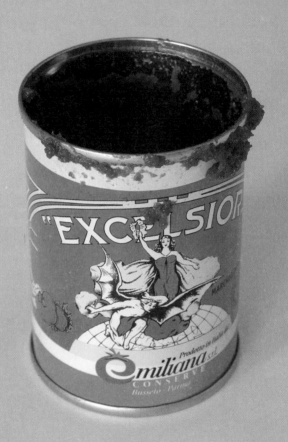

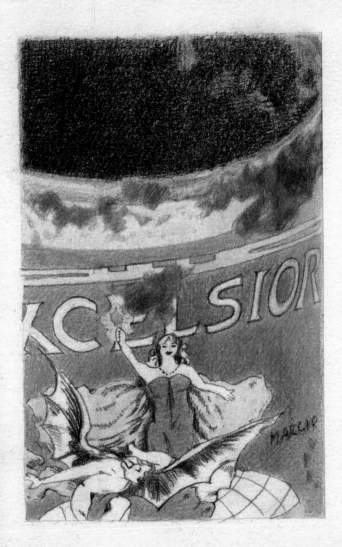

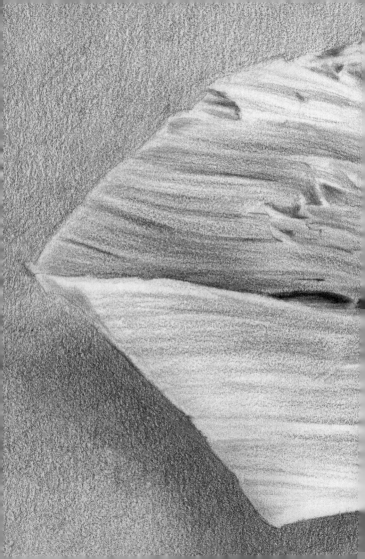

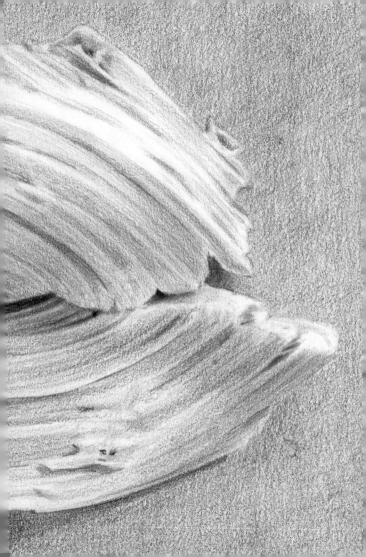

14

Change of Use

Plates, platters, pans, cake tins, cutlery, and other kitchen utensils are all familiar to us from their conventional functions and positions in the kitchen. Only by rearranging them, reversing them, or focusing on their details can we discover formal qualities that are usually hidden from our eyes. When we look at a bowl, we notice its concavity—which after all is crucial to its function as a bowl—not its underside bulging towards us. Deliberately "misuse" objects to gain a new perspective of them.

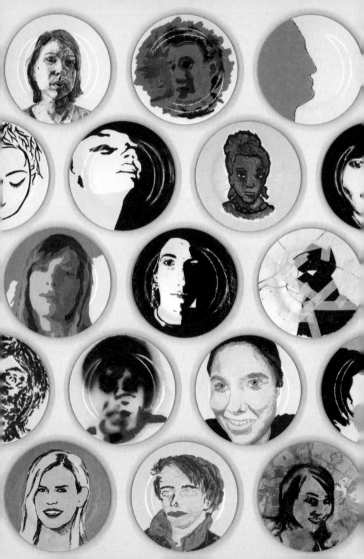

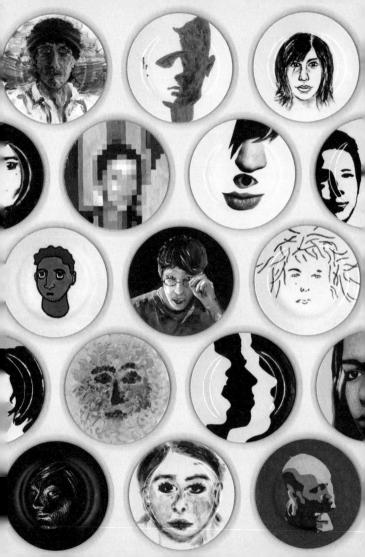

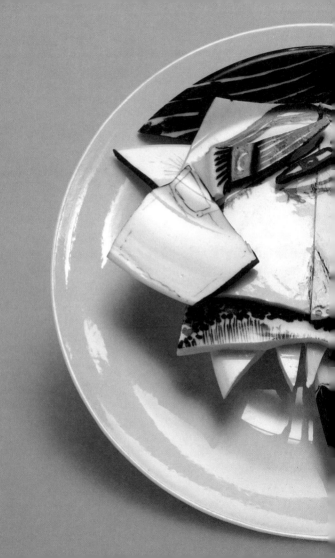

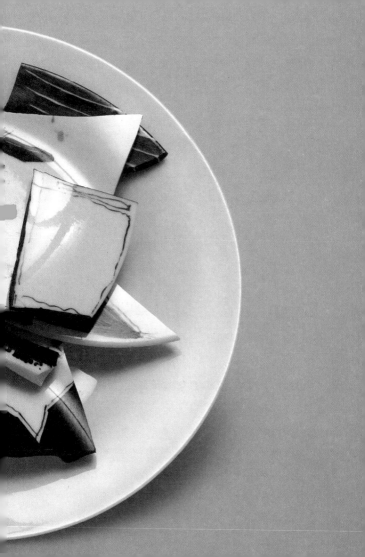

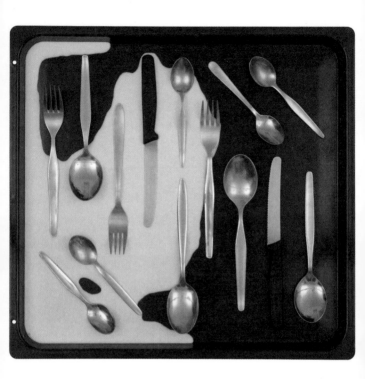

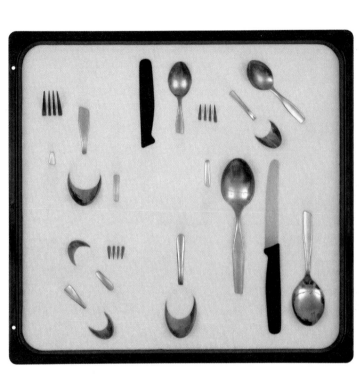

 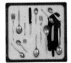 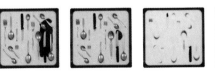

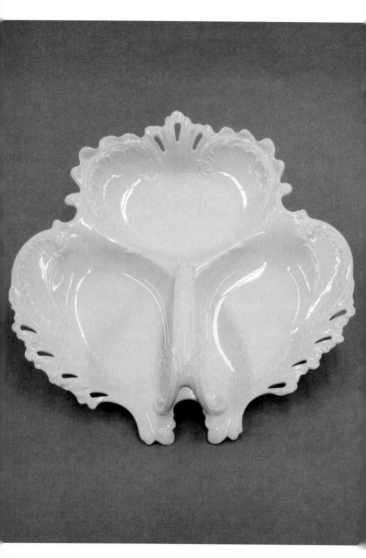

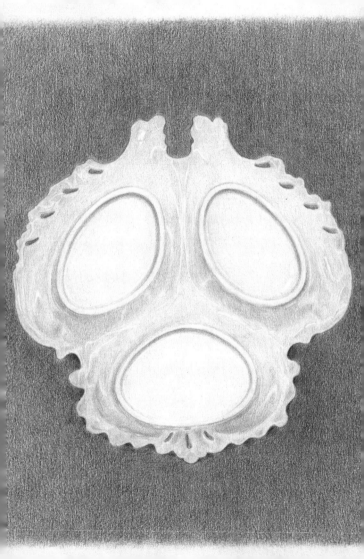

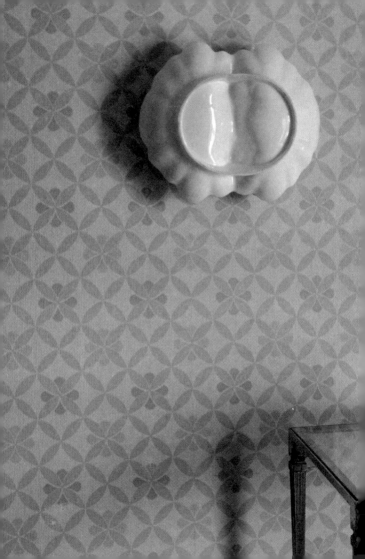

15

Objects

Usually it is artists and designers who design objects, especially those that survive the test of time. Things that come with a sell-by date or that are created only for the moment are scarcely considered objects at all—unless you make something out of them, create something out of the fleeting moment, of the commonplace that warrants longer-term appreciation. Create your own objects or sculptures using whatever inspires you in your kitchen.

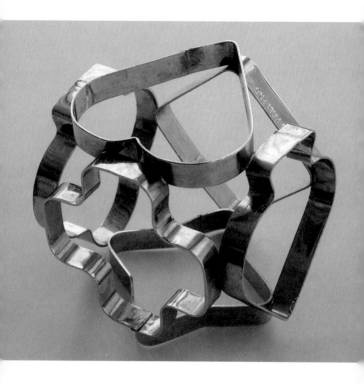

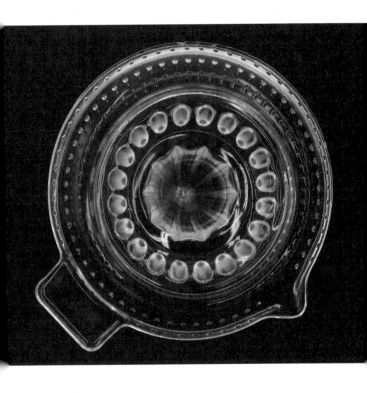

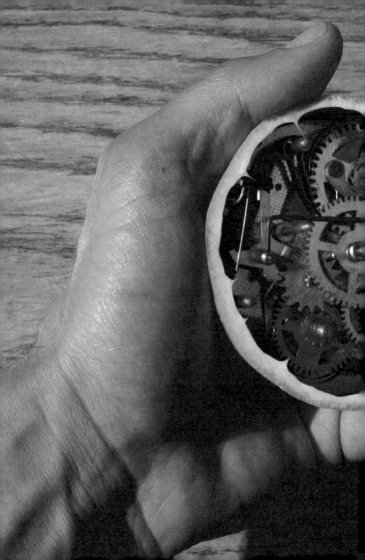

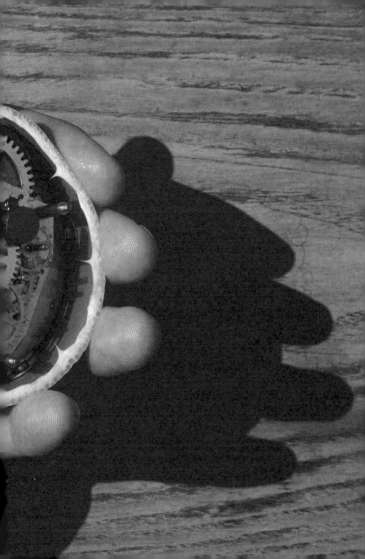

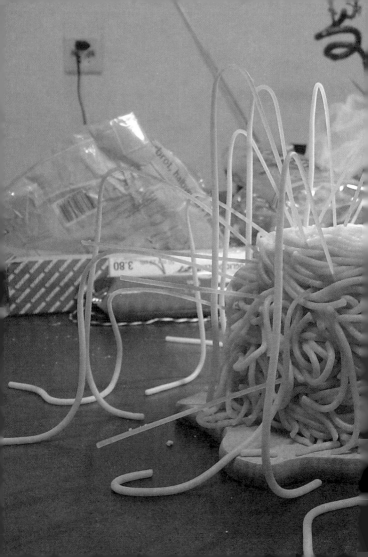

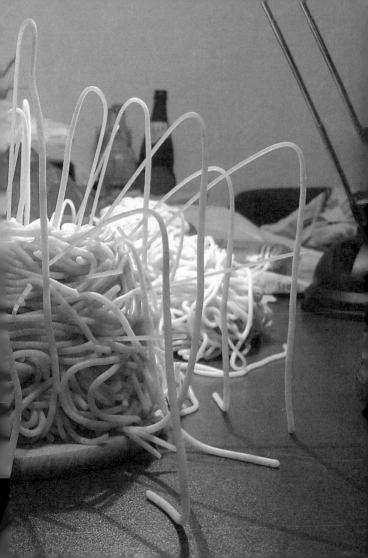

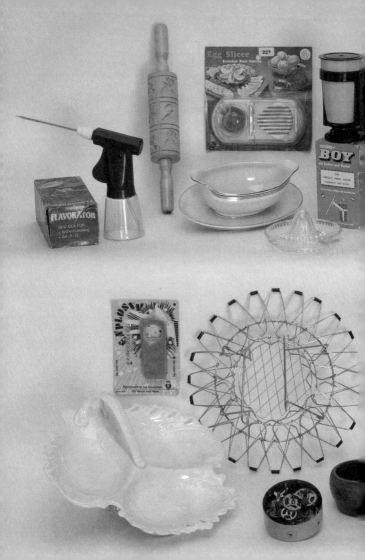

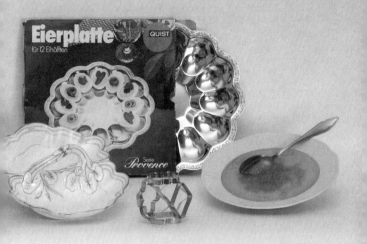

16

Compressing

Discarded objects, broken things, and packaging generally end up in the garbage, where their erstwhile dimensions are usually minimized as far as possible. Crushing, squeezing, compressing, and bundling are among the most important methods used in the waste disposal industry, and it is hardly by chance that every kitchen these days has a garbage can somewhere, hidden from view but readily accessible. Be inspired by the techniques of compressing, bundling, reshaping, consolidating, and squeezing and apply them to different kinds of food and produce instead of packaging.

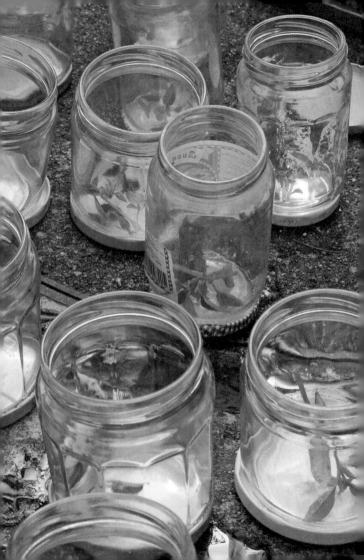

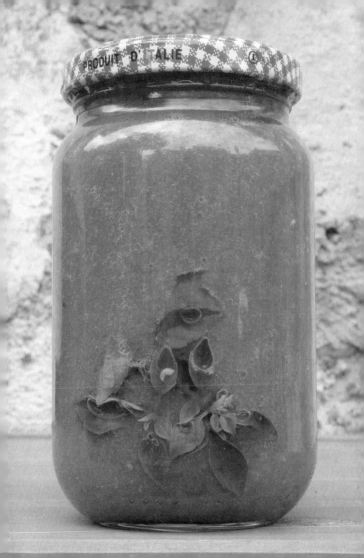

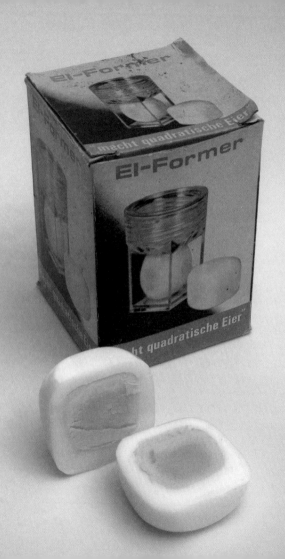

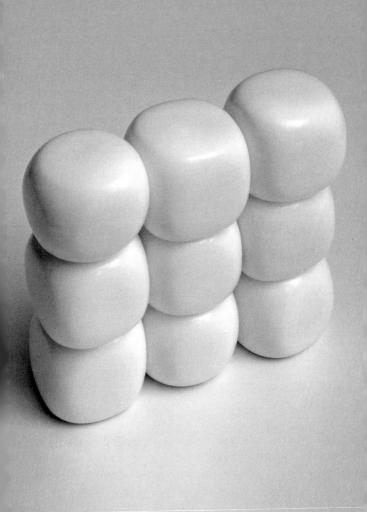

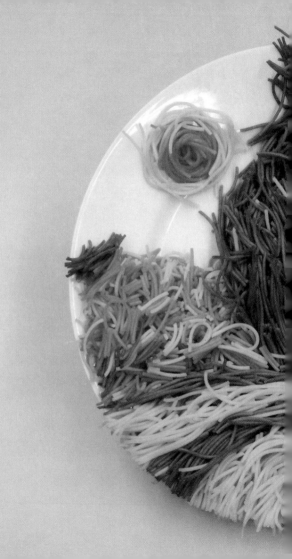

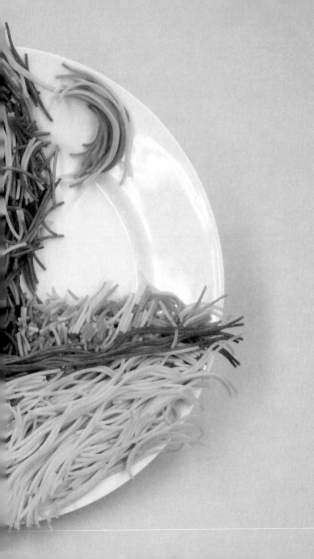

17

Hoarding

Cabinets, vitrines, and containers of all kinds attest to what we consider worthy of preservation and protection. Whether something serves merely for storage or is used for presentation is bound to influence our perception of the objects it contains. By removing some things from sight and showing others to best advantage, a museum can turn its vaults into another gallery.

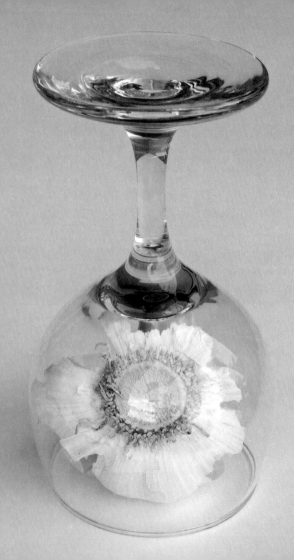

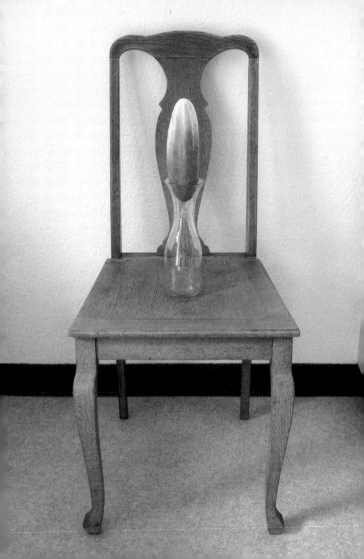

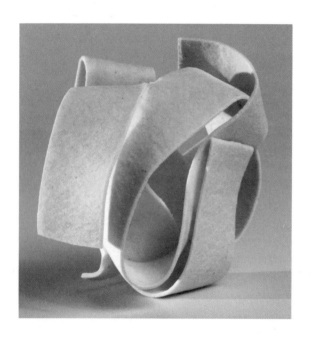

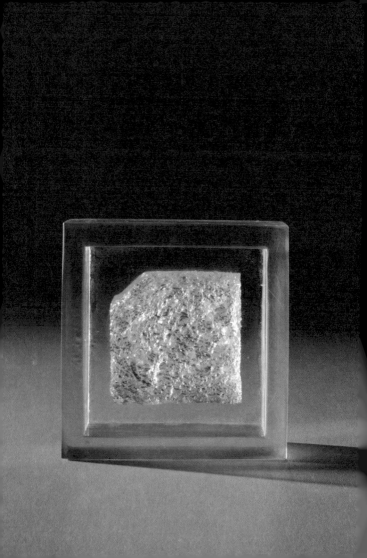

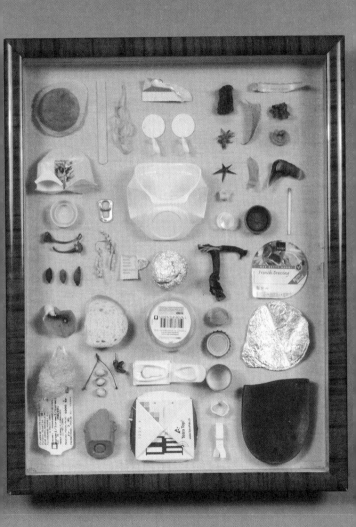

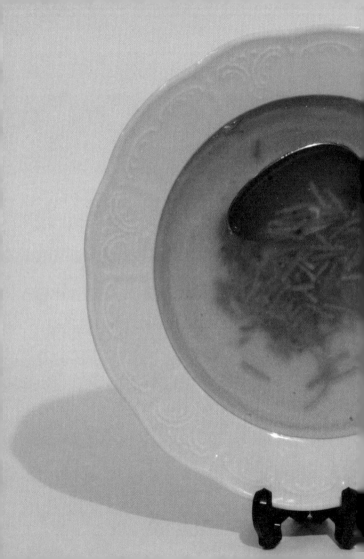

18

Comparing

Comparing exposes differences. Some things are diametrical opposites (like black and white, for instance), but when we compare and contrast things we can also perceive subtler nuances, such as the same content in a different form (e.g., piping bag and tube), or the same form with different content (pitchers with faces, see pages 196–97). What comparisons do the objects in your kitchen invite?

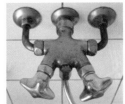

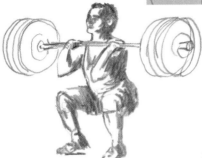

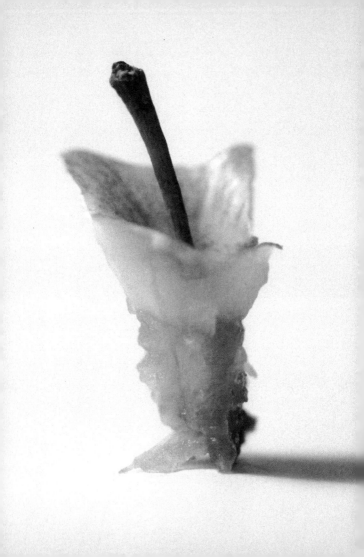

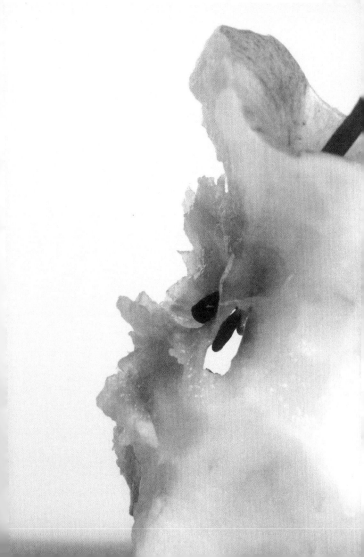

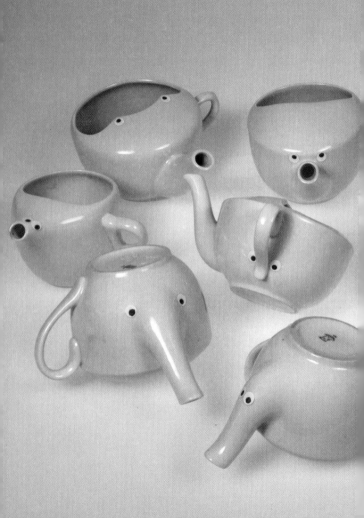

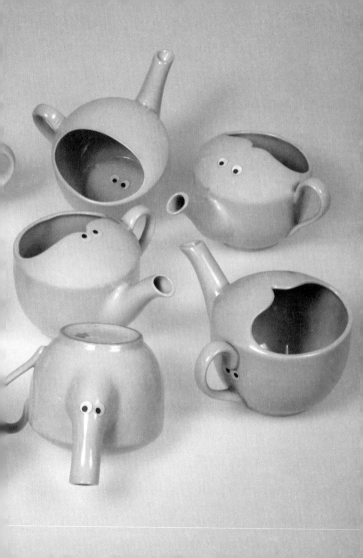

19

Transfer

When Marcel Duchamp catapulted an unchanged bottle rack into the museum, he revolutionized the way we look at art. Today we no longer even need an art space to appreciate the banal; an eye that is receptive to art can appreciate a banal object as art even in its natural environment.

Pages 200–1: From Mc Donald's to McFondue
Pages 202–3: Sea of ice

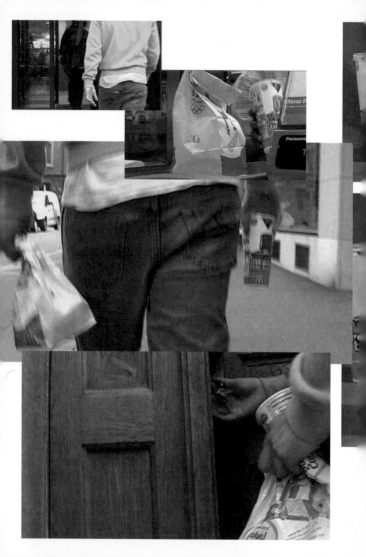

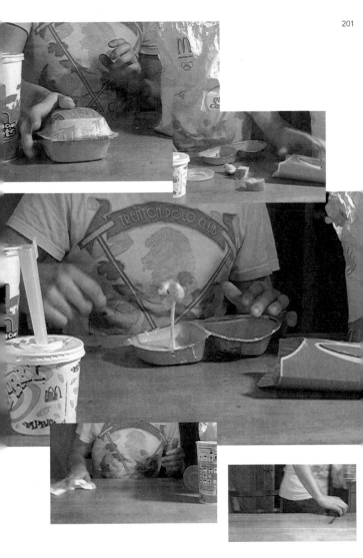

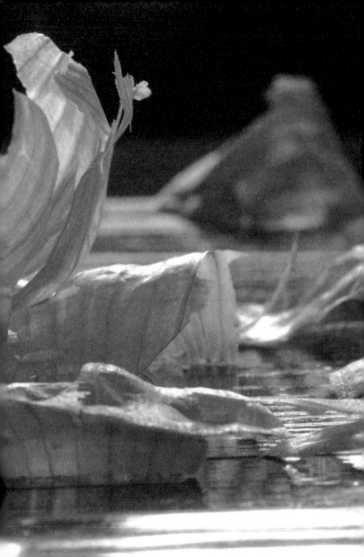

20

Performance

Performing, playing, and enacting are all elementary creative techniques and forms of representation. Role play has long been a basic method of learning by doing for children, just as performance is an important part of art history. Whether you choose to call them self-presentation, biography, or role play, the essential aspects and elements of performance are apparent in all of the different forms and media presented in the following pages. Be inspired by the space or objects of your kitchen to put on your own performance.

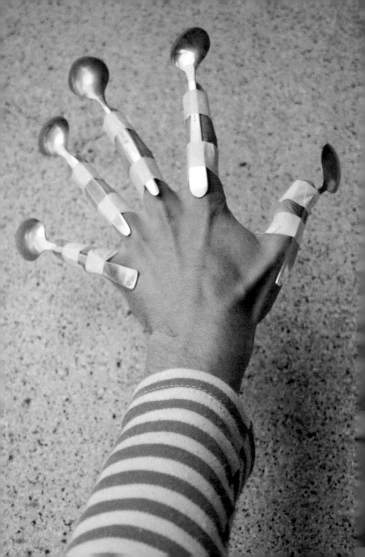

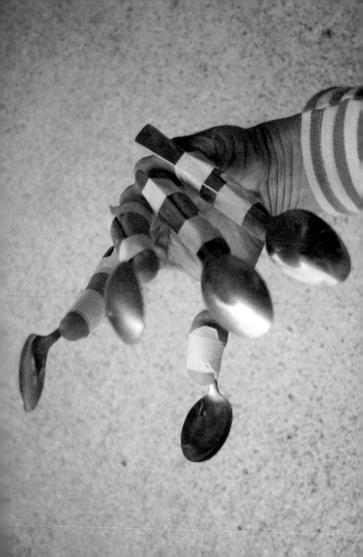

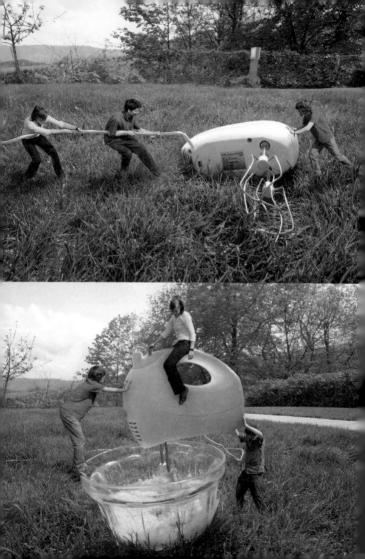

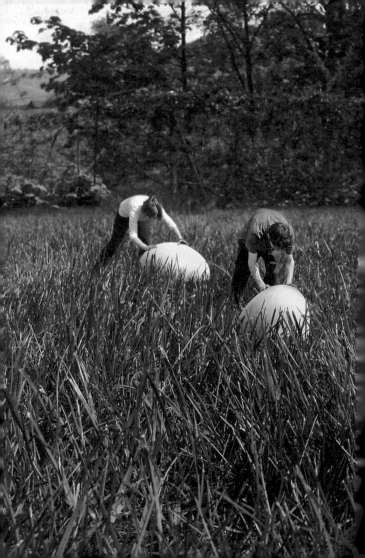

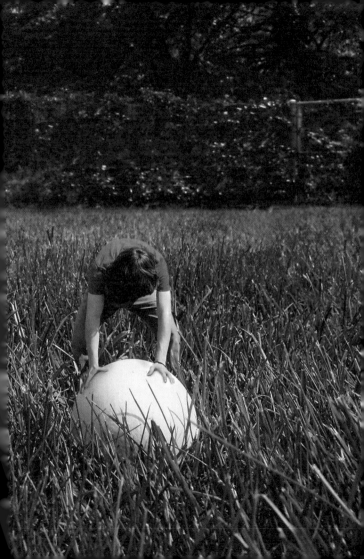

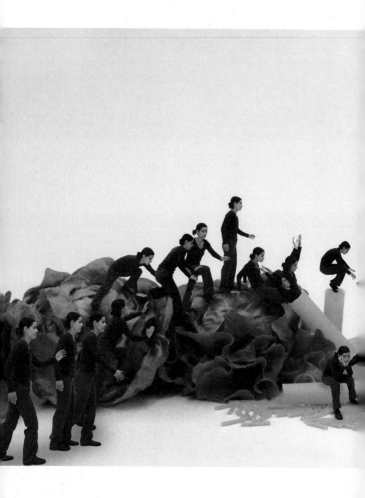

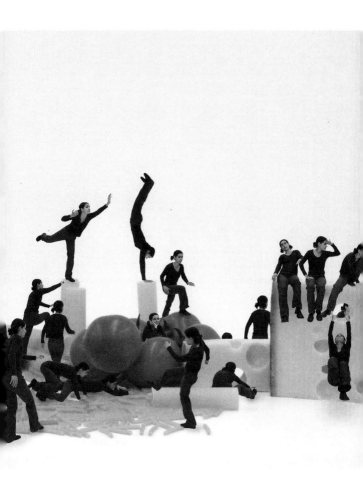

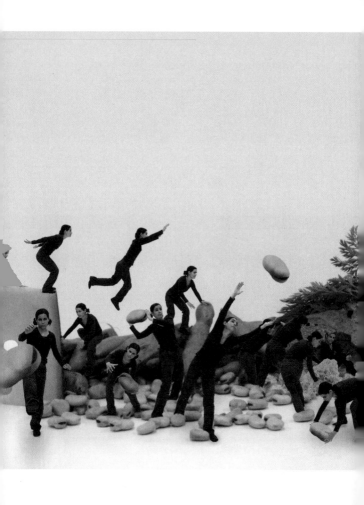

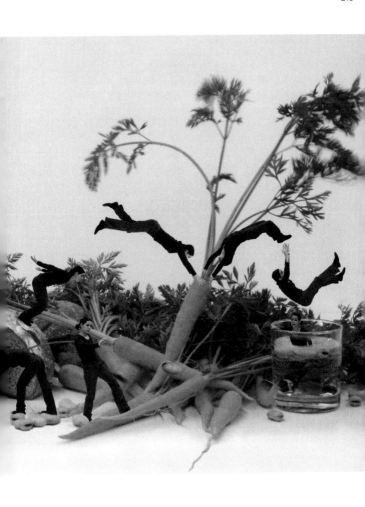

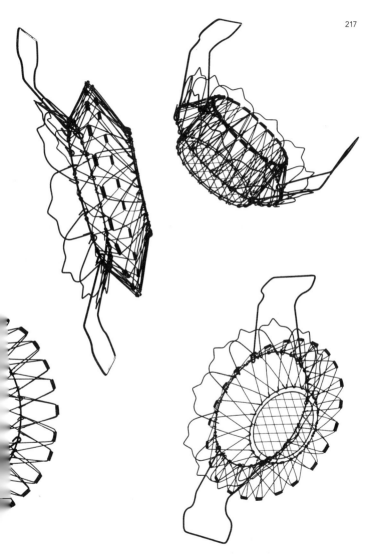

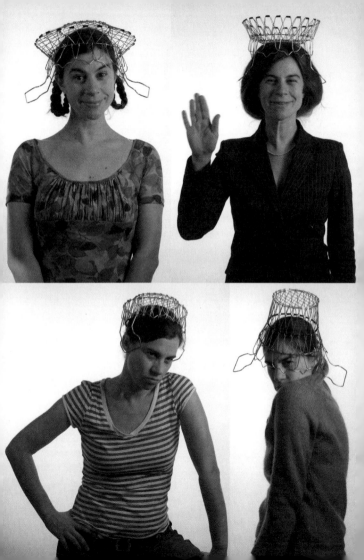

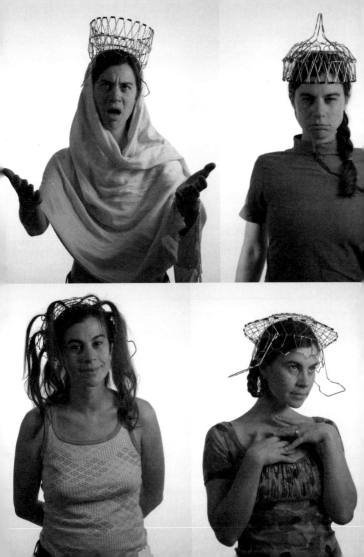

21

Metamorphosis

The essence of cooking is transformation, which can lead to a wealth of creative forms. Observe and record these processes of transformation and you'll make some surprising discoveries.

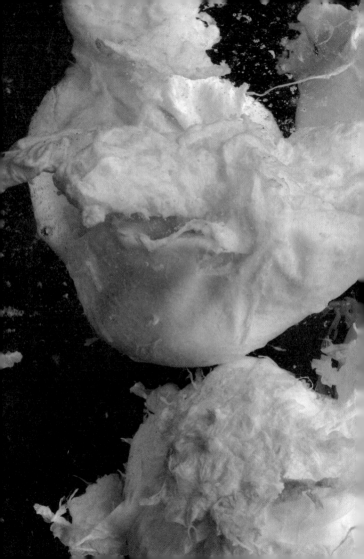

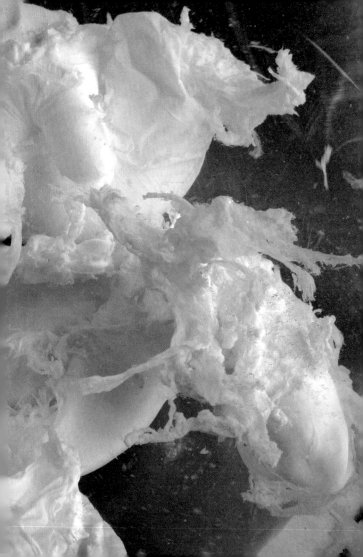

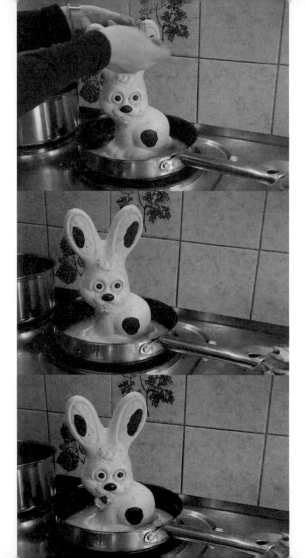

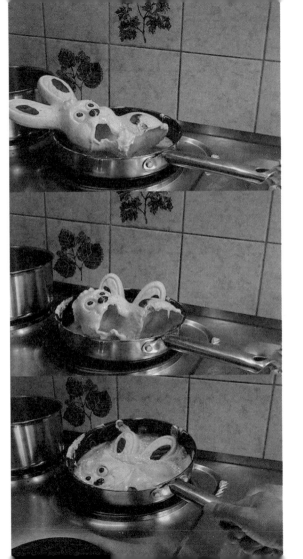

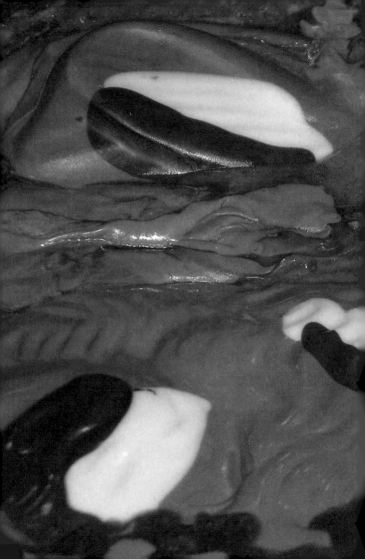

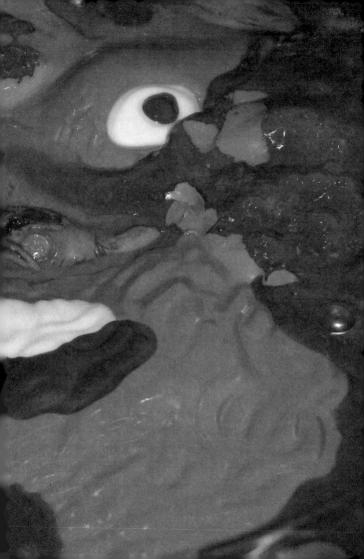

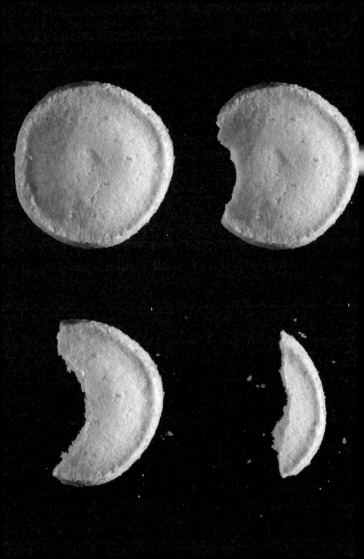

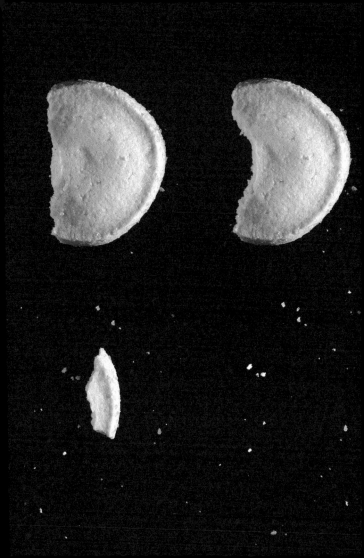

22

Comics

We are all familiar with comic strips, which combine graphic representation with the art of narration in a simple yet vivid way. Comics make a great vehicle of information (in recipes, for example), but can also become a form of artistic expression. Whether you choose to use comics as a means to convey information or to make art, have fun while experimenting with this medium.

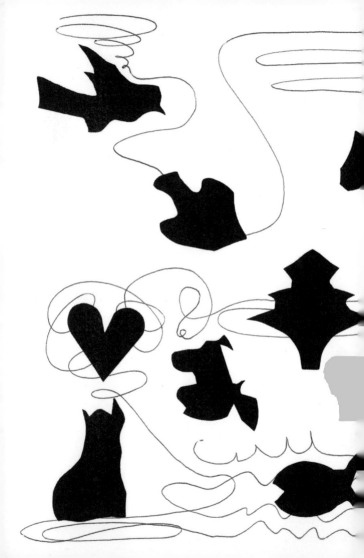

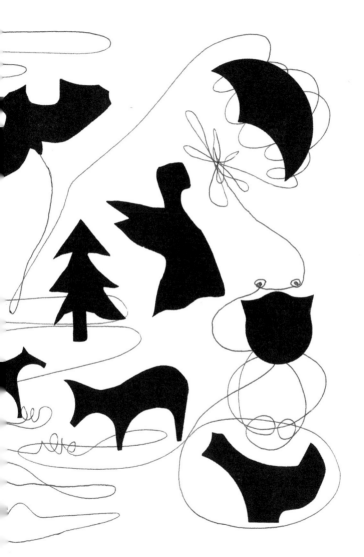

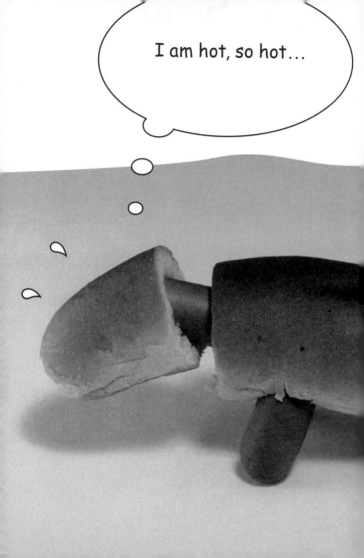

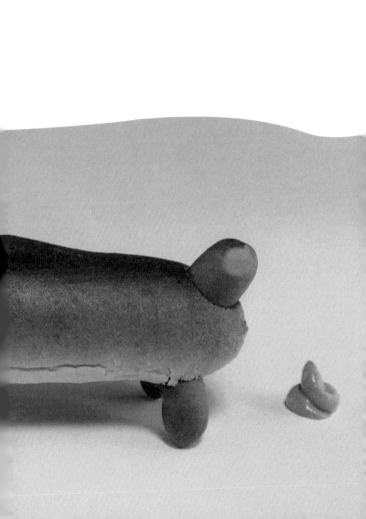